The Photoshop Handbook

Simple Ways to Create Visually Stunning and Breathtaking Photos

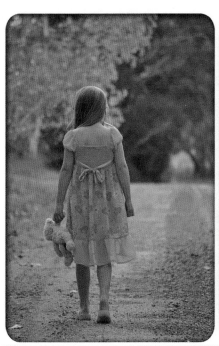
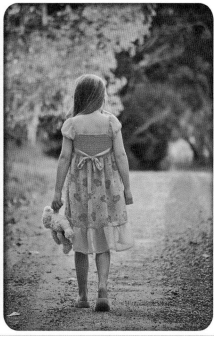

Table of Contents

The Photoshop Handbook

Advanced Ways to Create Visually Stunning and Breathtaking Photos

Introduction

I want to thank you and congratulate you for buying the book, *"The Photoshop Handbook: Simple Ways to Create Visually Stunning and Breathtaking Photos"*.

This book contains proven steps and strategies on how to enhance your photographs using one of the most popular and most user-friendly software in the market, Photoshop.

One of the most common misconceptions about Photoshop is that it's a way for photographers to cheat. It just might be, but you should understand as well that even the most sophisticated camera has its limitations. What we see with our eyes cannot be fully captured by any man-made device. The essence of a sunset over the sea, the serenity of a silent mountain, or the grandeur of a rushing river – these sceneries' ambiences and emotions will come out bland and lacking when printed.

It's not that you cannot instill life on pictures. There are simply some technicalities in machines that cannot compare to our visions. However, the good thing about modern technology is that it has created ways on how to replicate what we see on what we've captured, and one of the many ways is through Photoshop.

Some photographs are good on their own, but most can be further enhanced through the use of this amazing photo editing

software. In the following pages of this book, you will learn simple and foolproof techniques that will enable you to add drama, breadth, and life to almost any kind of picture. Also, you will understand how Photoshop functions and how you can use and apply each tool independently.

Go on and take a peek and see what this little handbook has to offer. Photos are our way of preserving a moment, so why not enhance them and make them guaranteed attention grabbers?

Thanks again for buying this book, I hope you enjoy it!

Chapter 1: Light and Levels

The first photo enhancing technique that will be discussed is so simple, it won't take more than ten minutes to apply. Some photos, after all, are best left almost untouched. If the angle is right and the subjects are well placed, little adjustments in lighting, contrast, and shadows are enough to transform any photo into a masterpiece. Just like with a naturally beautiful face, heavy makeup will only make it look less attractive.

An untrained eye may not notice this, but most digital photos somewhat have a thin gray layer on them. There's nothing wrong with the camera. Sometimes, the settings are simply not adjusted properly. Nonetheless, the objective in this chapter is to remove this gray layer and add intensity to the photo by darkening shadows.

Adjusting Levels

This is the most basic way of enhancing photos of all kinds. Unlike Contrast where it automatically adjusts the brightness and darkness of the *entire* photo when tweaked, Levels gives the option of allowing you to tune the complete or selected black area, white area, or midtones. This means you can *just* intensify the dark portions of the photo, or increase the brightness of the white parts, or find the balance between the two by adjusting the midtone.

Before proceeding to the step-by-step tutorials, you have to familiarize yourself first with the Levels dialog box.

How to access:

In the menu panel, click on Image. From the drop down menu, point to Adjustments, then select Levels.

How it works:

Once the dialog box appears, the first thing you will notice is the chart-like image. Below it are the black (left), white (right), and midtone (middle) sliders. These are the ones you'll need to toggle to redefine the "Input Levels" of the histogram.

Above this is a drop down menu labeled "Channel". Depending on your preferred histogram (RGB or CMYK), you can select which channel you want to tweak. For example, if the color you only need to adjust is red, then simply click on this drop down and select "Red". Afterwards, toggle the black, white, or midtone sliders to get your desired effect.

Application:

No two photos are the same, so you cannot set a fixed measure of levels for all. Depending on where the pictures were taken, under direct sunlight or between mist and fog, each will have different depths of darkness and intensity of brightness. This makes customizing level adjustments necessary for all.

Black and White Levels

Most pictures look best when full range light to dark is utilized. When you move the black slider to the right, the dark portions of your picture will deepen, and when the white slider is adjusted to the left, the bright parts will intensify.

> **Trivia!**
>
> Darker shadows are ideal even for portrait pictures. One reason why most models have preferably deep cheekbones (and why designers prefer them bone-thin) is because when the light hits their faces, shadows are cast, and this makes them striking. This is the same reason why eyeliners are a fad. If two equally pretty girls stand side by side and one is wearing eyeliner while the other isn't, the first one you'll notice is the former.

If you are working in front of your computer, try doing these simple adjustments. Afterwards, go to History, and undo your progress by clicking on the top tab. Notice how much the photo has improved. As mentioned before, it's like a thin layer of gray was removed. Go back to your latest progress by clicking on the last tab and restore your latest work.

Keep in mind, however, that not all sliders are necessarily adjusted. There are pictures with low light; hence, some areas are not fully black or white. If you adjust the black and white levels, you may only ruin the ambience of the image and make the light look unnaturally bright. In these cases, it's best that

you keep the adjustments to a minimum. Play with the sliders and see what best suit your picture.

Midtone Levels

The midtone slider functions similarly with Brightness. Move it to the left and the entire picture will brighten, and when you push it to the right, it will darken.

How is this best applied? Keep in mind that the goal of basic photo enhancement is to bring out the full black and full white portions of the picture. Sometimes, however, if you move the white slider to attain the fullest white of your photo, it will look overexposed. When this happens, you can adjust the midtone slider to balance the brightness, and maintain the natural look of your picture. The same instance can happen with the black slider, and you can utilize the midtone slider to fix this.

Precautions:

Be careful with using this tool, because you may end up increasing the contrast too much, and may lead to posterization. This means that your photo could look like one of those mass-produced posters with limited inks.

Also, changing the levels of channels in your histogram can cause color imbalance. If done incorrectly, your photo could turn out really yellow, too blue, or deeply red, unless, of course, this is the effect you want to achieve.

Photos Best Applied to:

Level adjustments are perfect for landscape photos. Cameras don't often capture the beautiful contrast of horizons and skylines because if the sun is too bright, it will automatically adjust its shutter speed to limit the intake of light. Therefore, the picture you took will look like it has a transparent gray layer on it. When you apply the above technique, however, you can bring out the blue of the sky without darkening the clouds and deepen the shadows of the subjects for additional drama.

Portraits can also benefit from this technique, but this will depend on the effect you want to bring out.

Focused Light Effect

If levels best suit landscapes, the focused light effect will best suit portraits. This technique will help you focus the attention of

viewers in a specific subject or area of the picture. Imagine the half-body photo of a girl with normal lighting. People's attention could be anywhere in the image, and you can make them focus on her face by adding somewhat like a spotlight.

This technique, however, requires familiarization of multiple tools in Photoshop. To make this tutorial more comprehensive, the functions of each will be discussed as you go along the step-by-step process.

Step 1:

Open the image you want to edit. Under the Layers tab in the panel at the right side of the window, click on New Adjustment Layer located at the bottom, then select Curves.

A new dialog box will pop up and you will see a grid with a diagonal line running through it. This line has small square ends, and you can adjust these to change the image's tonal range. The bottom left square represents pure black areas, while the upper right one represents pure white areas. If you play with this function, you will notice how the lighting of your photo changes.

For this technique, you need to drag the upper right square straight down until it reaches an output level of 70. You will see the output number at the bottom of the grid. Your photo will darken, and depending on the intensity of the effect you want to achieve, you can make it even darker by further dragging the square down. Click OK when you're done. A new tab will appear

under your Layers panel, and this shows the curve changes you've made.

<u>Step 2</u>:

For the next step, you need to select the area of the photo where the light will be focused on. There's no need to be precise up to the last pixel, so the Lasso tool will do. You can press the L key or go to the Tools palette and select it from there.

If you right click the Lasso, it will show three versions of the tool. The top most shows a round one, and this has the most basic function. In the middle is a polygonal one, and it is perfect for to-the-last-pixel selections. At the bottom is the most advanced among the three, the magnetic lasso.

For this technique, the most basic will do just fine. Click, hold, and encircle the portion of the image you want to select. You don't need to create a perfect circle for this. For example, if you are working on a portrait of a girl, you can roughly trace her face all the way to the shoulders.

Reminder!

The aim of photoshopping is to create believable effects, so you have to imagine which parts of the girl will be illuminated if you direct light on her face. Just because you want the focus on the face, it doesn't mean it's the *only* part you need to select. Observe portraits with high contrast in magazines, and learn how light falls on subjects.

Step 3:

You will see two layers under the Layers panel. At the bottom is your photo, and on top of it is the curve mask. If you click on the eye beside the latter, the dark layer on your photo will

disappear. This is what's amazing with Photoshop; instead of applying the change on the image itself, it created a new layer with a thin black film. If you change your mind later on about making that adjustment, you can simply delete the layer, and keep your original photo intact.

In this step, you will have to cut the selected portion off the black film, so you have to make sure the curve mask layer is selected. Click on Edit from the menu panel, and on the drop down menu, select Fill. A dialog box will appear, and beside Content is another drop down menu. Click it, select Black, then click OK.

If you look at the curve mask layer thumbnail, you will see that your selection turned black, whereas in your photo, the selected portion seems to have been cut out from the thin film.

Step 4:

Since the edges of the thin film are sharp, you would need to add a blur effect to make it look like light is shining over the subject. There are many ways on how to do this in Photoshop, but the most apt for this process is the Gaussian Blur. You will find this under Blur in the Filter tab, which can be found in the menu panel. Again, a dialog box will appear.

At the bottom of the box is a slider. Tweak it to increase the pixel radius. Look at the photo and you'll notice how the edges of the film lightened. Depending on what effect you are looking to achieve, you can expand the blur further, or keep it to a minimum.

Tip!

Great artists rely solely on their eyes to judge if the lighting effect is good and if it's correct. If the lighting style you want to achieve is similar to that of a spotlight's and the subject is far from the camera, then a wider blur is more appropriate. However, if the subject is near the camera and if your selected portion covers almost 60% of the canvas, then it is best to stick with a narrower blur.

Once you feel satisfied with the adjustments, click OK. By this time, you'll already see that the Focused Light Effect has come to life.

If you think the black film's darkness is too much, you can always adjust its opacity. Again, make sure that the curve mask layer is selected. In the upper right portion of the Layers panel, look for Opacity. From 100%, adjust it to a lower percentage until you think the darkness is just right.

Photos Best Applied to:

When you're done, the improvements will leave you stunned. Although focused lighting effects are recommended for portraits, you can also apply these in landscape and macro photographs. For example, this technique can add drama to a seemingly peaceful meadow. You can darken sky, then leave a bright portion somewhere between the clouds to make it look that some heavenly miracle is about to happen. For macro shots, if the main subject is a small insect on a background of colorful

leaves and flowers, you can emphasize the little guy by adding a conscrvativc light effect.

Level adjustments and focused lighting don't need to be done separately. You can apply these two photo enhancing effects on one image if you think it will bring out the best in your masterpiece. However, if you have a good eye for design and graphics, then these two techniques will barely satiate your need for stun. Hence, the following chapter will discuss more advanced Photoshop tricks and magic to make your photo not only stunning, but also breathtaking.

Chapter 2: Advanced Photo Enhancement Techniques For Portraits

Some photographs will benefit from more than simple shadow adjustments and lighting effects. Even if the quality of the image is top notch, some details can be improved to make the photo ever more striking.

This, however, will require further knowledge on the basics of Photoshop. Nonetheless, this book will provide a foolproof step-by-step of the techniques. Additional descriptions will also be supplied to help the reader familiarize with the tools and how they function beyond their use as displayed in the following techniques.

Most female readers are probably waiting for the Photoshop tricks that will make their skin glow like those of modern vampires in movies and TV shows and give their faces that natural blush and thick eyelashes. Good news, ladies! This portion is where all these will be discussed.

To all the gentlemen reading this right now, don't think you wouldn't need to learn these. Who knows, the lady of your dreams may ask this simple request sometime in the future. By that time, at least you'd know a few simple and subtle tricks to make her stand out.

This tutorial will teach you how to beautify (as the title suggests) a portrait. Hence, this applies best to subjects with little or no make-up. Understand, however, that this does not literally mean you will add lipstick, eyeliner, and such. The goal is to make the subject stand out without sacrificing his or her organic look.

Also, make-up for parties and those for pictorials are different. Gorgeousness in a person isn't always captured by the camera, so some tweaking may be necessary.

Depending on your evaluation, you can apply all of the following on one photo, or just a few selected. Some features may not need enhancing if you think they're already perfect, like the glow of the skin, for instance.

a. *Skin Tone*

Unfortunately, using Photoshop to get an instant tan isn't the essence of photo enhancement – that's already manipulation, and we'll try to stay away from that as much as possible. Simple and natural enhancements on the skin means giving color. Some subjects may appear grayish or extremely pale, and to make them stand out or glow, you have bring out a bit of yellow and red.

To do this, you need to toggle the image's hue and saturation. In the menu panel, go to Images, then point to Adjustments, and then click on Hue/Saturation. There will be three sliders in the dialog box that will pop up, and they are labeled accordingly. You can try to play around

with all just to see how it will affect the image, but for the purpose of enhancing your subject's skin tone, you only need to toggle Saturation. Bump it up to around 35% and observe the improvement. Your subject will instantly display a healthier glow.

Take note that the background will also be saturated along with your subject. Generally, this is good, because you'll be improving the color of the entire picture. However, if you want to focus the effect solely on your subject, then there are two ways to achieve it:

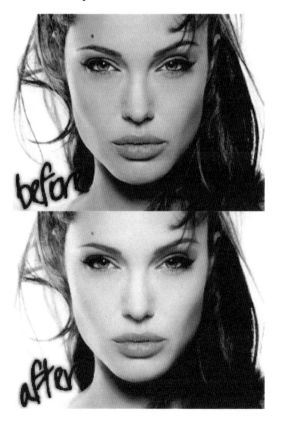

1: With the Polygonal Lasso (discussed in Chapter 1, Focused Light Effect)

This method is perfect for making the subject's skin appear naturally redder. Use this tool to trace the area where you want to apply the effect. Unlike earlier, you have to be precise this time, otherwise you'd leave inconsistencies in the image, hence, losing the "natural" effect. Afterwards, right click on the image, then select Layer via Copy. This will create a new layer out of the traced portion, and you'll see this under the Layers panel. Select your new layer, then follow the above instructions to modify its saturation.

2: With the Gaussian Blur

If you experimented with the Focused Light Effect in

Chapter one, then you're already familiar with this technique. The difference this time is that you'll be tweaking the photo's saturation.

This time, look for the Hue/Saturation option under New Adjustment Layers at the bottom of the Layers Panel. The dialog box will appear, then adjust the saturation to your satisfaction. Select the round Lasso, then trace the area where the effect will be applied. Just like before, there's no need for precision in this method.

Once the outline appears, right click on the image then choose Select Inverse. The outline will extend to the border of the photo. This step is necessary, because unlike what you did in the previous chapter (where you removed the traced portion from the film), you will apply the effect *on* the traced portion.

Afterwards, go to Edit, then select Fill. In the dialog box, click on the drop down menu beside Content, then select Black, and click OK. You've seen this happen before, only with different effects, and you already know what's coming next -- the Gaussian Blur. From the menu panel, click on Filter, then point on Blur, and then select Gaussian Blur. Adjust the slider at the bottom of the dialog box to blur the edges of the layer.

You may think the only difference between the first and second options is the method, but there is also a

difference in effect. The Gaussian Blur technique won't simply brighten the skin, it will make it glow.

b. *Lips*

If you can't get a tan on that skin, then perhaps rose red lips will do. Just like before, there are two ways on how to get this done. The effect, however, will be different. In the first method, the subject will appear to have lipstick on. Whereas in the second method, it will seem that the subject has natural red lips.

1: Lipstick Effect

If you paid attention earlier, then this method will be a piece of cake. The process done under the Polygonal Lasso technique in modifying the skin will be replicated here. However, there will be additional functions to

toggle at the end of the process.

Using the Polygonal Lasso, precisely trace the lips of the subject. Complete accuracy is highly important in this method, otherwise the effect will look like it was Photoshopped (We both know it is, but seamless work will have natural results no matter how or where you look at it.).

Tip!

To-the-last-pixel tracing will be a lot easier if you zoom in on the image. Look for Zoom in the Tools palette, then select it. Right under the menu panel are the buttons for the Zoom In and Zoom Out functions. If you are fond of shortcut keys, then press Ctrl and + to zoom in, Ctrl and - to zoom out, and Ctrl and 0 (zero) to return to the image's original size.

Right click on the image afterwards, then click on Layer via Copy. Select the new layer (the lips cut out) in the Layers panel, then access the Hue/Saturation dialog box through the menu panel and adjust accordingly. You can play with all three sliders to get the right mix. If you want to change the color of the "lipstick", then open the Color Balance dialog box and tweak it from there. It is located near the Hue/Saturation function.

2: Natural Red Lips

The difference between rose red lips from one with lipstick on is gradience. Edges and corners are well defined when you have make-up. If you rely on blood for color, however, the inner portions of the lips will have a different shade from the outer. Therefore, the goal of this method is to bring out the red in the inner parts, and let it gradually tone down to the lips' natural color.

Again, Gaussian Blur will be utilized to achieve this effect. Through the New Adjustment Layer, select the Hue/ Saturation function, then adjust the sliders to get your desired effect. Since the lip area is small, it is advisable to use the Polygonal Lasso instead of the round one. Keep the outline inside the lips, because when you blur this, the effect will spread. You don't want the subject to look like she smudged lipstick (and failed to remove it completely) all over her mouth.

Right click on the image then click Select Inverse. Go to Edit on the menu panel, select Fill, then choose Black in the drop down menu. Afterwards, apply the Gaussian Blur. It's up to you to judge on how blurred the layer should be. If you need to re-adjust the saturation, then simply double click the layer's thumbnail in the Layers panel. The dialog box will re-appear, and you are free to toggle any of the three sliders.

c. *Eyes*

Following the trivia highlighted in the first chapter, adding depth around the eyes will make the person appear more striking. This technique, however, will not add eyeliners to the subject. Natural beauty remains the best, hence the enhancements to be done will solely focus on adding small and subtle changes and highlights.

Mild shadows on the outer corner of the eyes will make a huge difference on your portrait. For the first time in this handbook, you will make use of the Brush tool. Before you click on it, however, press the L key first to use the Lasso and trace the general eye area -- from under the eyebrows to above the cheekbones.

As the outline flashes, go to the Layers panel and click on the New Layer button at the bottom. Keep your new layer selected then press the B key to select the Brush. Right under the menu panel, you will see additional options that can customize the size, type, opacity, and such of the tool.

Alter the size of the brush depending on the size of the eyes. Simply imagine you're adding eyeliner to it to give you an idea of measure. If your settings are right, your mouse pointer will show the ring size of your brush. You can adjust this through the additional brush options under the menu panel, or by pressing the] key to enlarge

or the [key to reduce.

Changing Mouse Tips

Your cursor will not always display the selected brush size or type, and this makes it more difficult for you to estimate how big your brush is against your canvass. To change this, from the menu panel, click on Edit, then Preferences, and then select Cursors. A new dialog box will appear and it will show you different painting cursor types and how it appears. There are four options, but the most advisable for beginners is the Normal Brush Tip. Click OK when you are done, and you are free to continue your masterpiece.

Setting a fixed brush size won't help either because photos vary in pixel size. This means that if the pixel size of an image is small, brushes with narrow diameters will appear average or big. If your canvass has a large pixel size, however, the same brush size will appear tiny. Hence, if you are not familiar with these yet, it's best if your cursors are set this way.

Tip!

Doing effects and changes on new layers makes a wise choice, because if ever you change your mind later on, you can easily hide or delete the changes you've made, instead of going to the History panel to undo all of your progress -- and possibly undo the changes you like.

Furthermore, in a more advanced setting in Photoshop, there are instances where you will have to erase or clip unconventional portions. For example, when you did the Focused Light Effect, you had to make sure the level adjustments are done on a new layer. Otherwise, if you applied it directly on the Background image, you won't be able to cut the face of the subject without damaging the original image. In other words, do not apply any changes on the Background layer.

Once you feel the brush size is just right, add a soft shade at the outer corner of the eyes. You can adjust the opacity of the effect on the Layers panel, or adjust the opacity

of the brush before applying it on your canvass. If your default color is black, however, and you want to make the shade look natural and close to the complexion of the subject's skin, click on the color boxes near the bottom of the tools panel. A dialog box will appear where you can select the specific color you want your brush to have. Once you are done, click OK and proceed with the coloring.

d. *Cheeks*

Adding a soft blush is the easiest Photoshop trick in this handbook. Take note, however, that this technique is just a simple way of adding color to the face, and not a way to make the subject look like she's wearing foundation and concealers. The only tool you will need here is the brush.

Before you proceed with applying the virtual blush-on, make sure to create a new layer as tipped earlier. Afterwards, press the I key, or select the color picker from the tools panel, and click on the lips of the subject. Unlike the first method described earlier, where you select the color by clicking on the color boxes, using the color picker will help you get the exact same pigment of the chosen area.

Afterwards, select the brush tool, then tweak its settings to imitate the effects of a makeup brush. Opt for a large diameter – one almost as wide as the cheeks – and make sure you select the gradient type of brush, and not the

one with a well-defined ring. You will find the brush types right under the menu panel. Lastly, set the brush opacity low – 30% or lower will do, depending on your preferences – then apply.

Note!

If you adjust the opacity of the brush itself, make sure to apply the blush in one stroke. Otherwise, overlapping portions will have darker shades.

If you don't get to apply it properly (for instance, you accidentally brushed on the eye), you can always use the Erase tool to remove parts you don't like. This is highly similar with the Brush tool, because they almost have the same options and selections, but instead of adding color to your canvass, you erase them. Since your blush-on effect is on a new layer, when you erase parts of it, the background layer won't be affected. For consistency, it is recommended that you use the same type of brush and size for the Erase tool.

e. *Skin*

Of all the beautifying Photoshop techniques in this handbook, learning how to remove wrinkles will probably be the most sought after. After all, this is usually the very first thing people would request you to remove or improve.

Understand, however, that this technique will require intermediate Photoshop skills, unlike the ones discussed previously. If you are a beginner, then you may find the instructions a little confusing. Therefore, it is best to follow the steps below while in front of the computer.

One common problem in removing wrinkles is that people remove the skin's texture completely, and this is what you want to avoid. Again, your image will appear as if it has been Photoshopped if you do that. To address the problem, you will have to use two layers of the image and apply different effects on them. The first one will have the details and texture of the skin, while the second will hold the tone and color.

Step 1:

On the background layer (or a duplicate of it if you prefer applying all changes in new layers), clean the bumps, spots, and other skin imperfections using the Healing Brush tool. You can press the J key to instantly activate it, or locate it in the tools panel. No settings should be necessarily tweaked to get things right. You only need to use it like you would the brush tool.

After freeing your subject's face from the imperfections, you'd be surprised with the massive change. This, however, is merely the first stage of this technique. In the

following stages, you will transform the skin to that of a soft velvety petal.

Step 2:

Create the two layers discussed earlier by duplicating the background layer twice. In the Layers panel, right click on the said layer, then select Duplicate Layer. Repeat the process to create the second copy.

For easier reference, you can change your new layers' names to Texture and Retouching. Simply double-click on the "Background Layer Copy" text on the layer tab, then rename. This way, it will be easier for you to discern what adjustments should be applied to which. Keep the Texture layer above the Tone layer.

Select both tabs then click on the Group button at the bottom of the Layers panel. Keep the selection on the Group tab, then go to Layer, Layer Mask, then click on Reveal All. This will produce a Mask over your layers.

Masks are used to avoid affecting parts of the image that should not be applied with the effects. If you are working on an image of a person, and you are removing wrinkles, these untouchable parts would be the eyes, hair, mouth, and such. Keep the mask as is for the mean time. You will use it in the latter parts of this tutorial.

Step 3:

Hide the Texture layer next because the following adjustments will be applied on the Retouch layer. Simply click on the eye icon beside the tab. Hiding it will enable you to see the changes you've made in the Retouch layer. Otherwise, it will appear that you are not making any progress by keeping the Texture layer visible.

As utilized before, you need to make use of the Gaussian Blur to soften the image. Unlike in other techniques, however, you have to be careful not to spread the pixels too much. For the more advanced users of Photoshop, you can use the Surface Blur function instead. This will give you additional options to tweak and play around with, thus giving a more appropriate blurring effect. By now, you will notice how the subject's skin has glowed and softened. The edges, however, became less defined, but that's why you're keeping the Texture layer.

Step 4:

Still on the Retouch layer, use the brush tool to paint on parts of the subject's skin you don't like (e.g. deep wrinkles like laugh lines, shadows, or eye bags). Keep its opacity low (preferably at 20%), and opt for the soft type of brush to avoid defining edges. Before applying anything, hold the Alt key and click over the surface of the skin's color

you want to adapt -- the color that will lighten unwanted details on the skin. As tipped in applying blushes on the cheeks, make sure you accomplish the lightening in one stroke, otherwise the opaque color will overlap.

At this stage, you may be thinking that the skin is good as it is. The wrinkles have been removed and the subject would have looked like a model of a moisturizing lotion. Keep in mind, however, that the skin's texture needs to remain to keep everything natural.

Step 5:

In this step, you will tweak a few things on the texture layer, so you need to unhide it. Simply click on where the eye icon was to make it appear. Don't panic if the changes you've made have disappeared. The Texture layer is above Retouching in the Layers panel, so it's just normal that if you unhide the latter, it will cover the former.

The next thing you need to do is adjust the noise of the image. In some cases, this function heightens the details by playing with the smallest bits of color. Ideally, you would need to download a Noise Ninja Plugin to get the perfect texture, but its functions are highly advanced and you may encounter problems in the installation process. Therefore, you will have to make do of the Add Noise function. You will find this under Filter, and then under Noise.

Once the dialog box appears, feel free to toggle and tweak every slider and check box just to see how it would affect the image. This will give you a better idea on how to set and get the ideal noise. Basically, what you want to is minimum enhancement on the details. Don't go overboard in tweaking the slider; otherwise, your image will end up looking like a colored newspaper print. What's important is to make the texture visible enough. If the Noise tool cannot pull the best effect, you can try increasing the contrast of the image. Simply go to the menu panel, click on Image, point to Adjustments, and then select Brightness/Contrast.

Step 6:

In this step, you need to merge the Texture and Retouching layers. The fastest way to do this is by changing the blending mode from normal. However, your image will appear burnt if you do this. Therefore, you need to adjust the High Pass settings first.

Make sure the Texture layer is selected. Then go to Filter, point to Others, then select High Pass. You can try experimenting with other measures, but if you are beginner, then the safest setting for the radius is 8.0. Afterwards, adjust the saturation to -100. Again, you will find this tool from the menu panel under Image, then under adjustments.

Once you are done with these two, change the blending option to Overlay. You will find this at the upper portion of the Layers panel. When this effect has been applied, you will see that wrinkle-free skin you've been working for. If, however, you feel that the glow was a little too much, you can strengthen the texture by further adjusting the contrast via the Brightness/Contrast tool.

Step 7:

For the finishing touches, you will have to utilize the mask you created in Step 2. Select it, then use the brush to paint black on the surfaces where the changes should not have been applied. Keep the settings in the soft type brush to avoid sharp edges.

When you think all details are good, you are done!

Many people are convinced that Photoshopping individuals is a way of cheating reality. You should understand, however, that only when this amazing software is used to alter certain features of the person should it be considered as such. For example, trimming a few pounds or enlarging the buttocks or breasts cannot already be considered photo enhancements. As you may have noticed, every technique discussed above are simple ways of bringing out color, adding depth, and improving texture. In other words, no alterations were made.

Therefore, whenever you feel you are cheating by Photoshopping a person's portrait, don't feel that way. As long as you are limited

to these and your intention is to simply make your subject stunning, then there's no harm done.

Chapter 3: Advanced Photo Enhancing Techniques for Landscapes

This is a handbook of simple Photoshop techniques, but as much as it wants to keep every tutorial easy and limited to only a few simple steps, some awesome effects sincerely needs intermediate skills. In the later part of this chapter, you will encounter functions, tools, and settings that were not mentioned before. This may sound intimidating, but this book will provide detailed explanations and steps to help you get the best out of Photoshop and your photos.

Also, to help you further widen your knowledge of the software, this book will discuss what effects are to be encountered whenever you make changes. Unlike other tutorials where they outline the instructions, but do not expound on what differences should be observed. Some filters, after all, show very little effect on the image.

The thing about landscape photography is that no matter how expensive your camera is, the raw beauty of nature cannot be fully captured all the time. Although some pictures are breathtaking on their own, most can be enhanced by tweaking a few aspects. There are also some effects that can be applied to make your photo more interesting, like making a cityscape look like a realistic toy town.

a. *Diffuse Glow Effect*

One of the easiest ways to make an ordinary photo an attention-grabber is by adding the diffuse glow effect. This will make your picture look as if it was painted with light – as if it was captured from a beautifully vivid dream. The defining feature of this effect is the glow it adds on the objects. If the blur is not too high, the details of the photo will merely appear soft.

Step 1:

After opening your image of choice in Photoshop, you can adjust the levels first to have a good balance of black, white and midtone colors before applying the effect.

Tip!

Portrait photography is entirely different from landscape. If in the former, depth and shadows are key in making subjects stunning, what makes landscapes breathtaking are 1) balance between light and dark, and 2) sharpness of details. Of course, the photographer has a giant role in incorporating these as they capture sceneries. However, as explained before, some aspects can be further enhanced through Photoshop. Therefore, if you think the clouds of the photo is too dark, or if the horizon needs a bit more brightness, then feel free to adjust them by adjusting the levels.

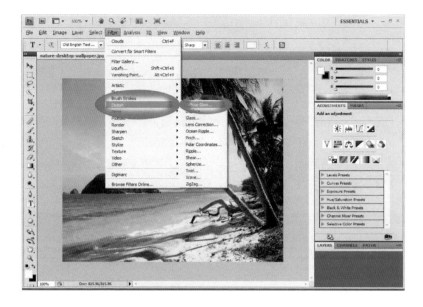

Step 2:

Duplicate the background layer. Go to the Layers panel, then right click the Background Layer tab, and select Duplicate Layer. A dialog box will pop up, and you simply need to click OK. You can also press the keys alt+ctrl+shift+n+e if you prefer shortcuts.

Step 3:

Make sure the duplicate layer is selected. Afterwards, use the Gaussian Blur once more, and adjust the blur of the entire image. It is up to you how soft it should come out, because it will depend on how deep you prefer the effect should be. Understand that the glow will come from this layer, hence, the wider the spread of the blur, the bigger

the glow of the outcome. As a general rule, however, it should not be soft enough to blur the details of the image.

Step 4:

This is where things get tricky. You need to blend the first layer with the Background layer, and there is no fixed option for all your pictures. Therefore, you need to try and see which will bring out the best in the effect and in your photo. Basically, this function will merge two or more layers, thus the colors will overlap each other. Depending on the option you will select, it can darken, lighten, saturate, etc. the image when applied.

You will see the blending options at the upper portion of the Layers panel. There are general rules to this as well, and it can serve as a guide if you are not sure on which to use.

- Darken and Multiply Blend. The overall feel you will get from this option is drama. These two will intensify the shadows and define the details with darker lines, and at the same time, add a halo-like effect on the objects.

- Lighten and Screen Blend. These two is the opposite of the previous blending options because they lighten and brighten the image. If highlighting glows and adding high keys are your target, then this is the blending you want.

- Soft Light and Overlay Blend. Landscape and still life photos are best complemented by these two, because they improve your photo's saturation and contrast.

If you've followed the above guidelines and the output still doesn't satisfy you, then you are free to experiment and see which blend will fit your needs.

b. *Tilt Shift Effect*

Capturing cityscapes, crowds, and streets is common for photographers. Intensifying shadows or balancing the black and white tones for enhancement purposes will bring improvement, but will barely make the image stand out. Therefore, you need to apply a more interesting effect to capture the crowd's attention.

Tilt shift is an effect that creates the illusion that a photo is of a miniature scenery. By blurring the background and focusing on a single part, the picture of a real baseball stadium would look like that of a highly detailed sports diorama. There are real tilt shift cameras in the market, but are remarkably expensive considering that it can only produce the said effect. Thankfully, there's Photoshop to give you the same stunning appearance, and in only a few easy steps.

Step 1:

Open the image you want to apply the effect on, and just like before, you can adjust the image's levels before proceeding with the main instructions. Also, you can duplicate the background layer to avoid applying the changes directly on the original image.

Step 2:

At the bottom of the tools panel, you will see a box with a circle on it; that is the Quick Mask Mode. Click on it and then select the Gradient Tool. You can press the G key for quick access, but it may give you the Fill tool instead of Gradient. If this happens, locate Fill, then right click on it and select Gradient.

There are different types of gradients, and you'll see the selection right under the menu panel. Choose Reflected Gradient and proceed to the next step.

Step 3:

Identify the area you want to remain sharp. If you are working with images of buildings in angled bird's eye view, then keeping the streets and entrances the center makes a good choice. On the other hand, if the picture has a focal point (e.g. a car, a group of people, a bench, etc.), maintain it as the center of interest by keeping it sharp.

Click the mouse on the selected area, then drag it vertically upwards. Keep in mind that the longer you stretch the gradient, the longer the area that will be kept sharp. So if you want a deeply blurred background, drag the gradient tool just a little above your focal point.

Once you release the mouse, a thin red layer will appear on your image. Click the Quick Mask Mode again and a selection line will outline where the red areas were.

Step 4:

Applying the blur will be the next step. You may have gotten used to the Gaussian Blur, and you can actually use that if you're comfortable with it, but it is more ideal to use the Lens Blur. This tool is located right under the Gaussian Blur.

A big dialog box will appear, and it will show a preview of your work. At the right are different sliders that you can toggle and play with to get your ideal blur. Just like all the previously mentioned adjustments, there are no fixed set of numbers for all pictures. Therefore, you need to rely on your graphic skills to see if the desired effect is achieved.

Click OK once you are done.

Step 5:

Your photo won't look toy-like just yet. To complete the effect, you need to adjust the saturation and contrast of the image. This step is optional, but highly recommended. The objects will appear as if they are made from plastic if you increase the saturation, deepen the shades and raise the contrast, making the "miniature scale model" effect more plausible.

c. *Montage Technique*

What brings impact in some landscape shots is the sky. Having well defined clouds, good light, and vivid skies can bring life into your photo. In fact, some commercial photographers keep stashes of sky photos in their flash drives in case they need to edit and add dramatic skies in their landscape or cityscape pictures. They cannot control the weather after all, and not all of them have the luxury of time and patience to wait for the heavens to shift to a more photo-friendly scene. What's important for them is to deliver breathtaking and seamless masterpieces.

Before you proceed with the tutorial, you first need to determine whether a sky shot will complement the landscape well. For example, the picture of a meadow will look even better with a blue sky and fluffy clouds. On the other hand, images of ruins or old buildings are better suited with overcast clouds and patches of golden

sunlight. You can download from the internet if you want to practice this technique, but later on, if you will use this for professional purposes, then buying or shooting your own will be necessary. The best places to capture great sky shots are on mountain tops, beaches, and deserts.

<u>Step 1</u>:

Firstly, open your landscape photo, and then your sky photo. In the former, begin by selecting the Wand tool from the Tools palette, or by pressing the W key. Right under the menu panel are additional options for the wand tool. At the far right, change the tool's tolerance setting to 20, then click on the Add to Selection icon located on the left side of the options bar.

You will use this tool to select the entire sky. Since it naturally has different shades and colors, when you click on the grayish areas with the wand tool, only one shade of gray will be selected. However, if you activate Add to Selection, it means that wherever and whenever you click the wand tool on your canvas, it will combine all the selections you've made. A more expert approach of doing this is by holding the Shift key while continuously clicking on the image.

Press ctrl + 0, or click on Actual Pixels when you change to Zoom. Afterwards, select the Quick Mask Mode at the bottom of the Layers panel (*not* the one on the tools

palette or else you won't perform the following steps correctly).

Step 2:

Define the details of the ground or buildings by using the Polygonal Lasso tool. Trace their edges and make sure you got the last pixel of sky separated from the foreground. It may seem that the wand did a good job on selecting the sky, and you can continue working with that. However, once you see your work coming to life, you will notice a white outline on your foreground objects. In the end, you'd still have to trace this out and repeat the process all over.

Once you are done tracing, click on the Fill tool or press the G key for instant access, then apply black color on your selection. Make sure that the selection is on the foreground and not the sky portions. Afterwards, exit Quick Mask Mode, or press the Q key to do so.

Step 3:

Go back to your sky image, then on the menu panel, enter Select, then choose All. Afterwards, go to Edit, then select Copy. Return to your landscape photo, then go to Edit once more, and then choose Paste Into. You sky image will position itself behind your foreground objects, and it will look bad as of the moment, but don't fret. The

tutorial has more secrets to share with you. In fact, this is just the beginning of real Photoshop magic.

Tip!

Montage techniques work best when the light of the two pictures is on the same side, or if they are taken in the same day. Imagine if you have a photo of a landscape taken at noon time. The sun would have been bright and the shadows are at a minimum. If the sky photo you have on hand was taken at near sunset, and orange is scattered all over low hanging clouds, then it wouldn't match your landscape. Furthermore, there will be shadows on your clouds, and although not everyone can pinpoint the minute differences when you put them together, they will feel that there's something wrong with your photo. Understand as well that no amount of Photoshopping can fix this, and still come out looking natural.

The bottom line here is whenever you're going to put images together, make sure they are taken at the same time of day and that the light is coming from the same side.

Go back to Select on the menu panel and Deselect the photo.

Step 4:

The following adjustments will be made on the image, so make sure you have transferred the selection from the mask. Transform the image to fit your landscape. You can either press ctrl+T or go to Edit, then select Transform. The image will have squares in the middle of all sides and corners. Drag these squares to fit the sky image on your landscape. If you don't want to lose the proportion of the photo, hold the shift key as you make the adjustments.

With the transform function, you can enlarge the photo and show only a specific portion of the sky – only if there are parts of it you don't want to include in the montage. Make sure, however, that it won't pixelize or else it would ruin the entire image. Zoom in on the parts where the two images meet (edges of the landscape photo) to check if they still carry the same quality. If they don't, then you have to reduce the size of the sky layer until their pixels appear equal. However, if the quality of one layer still seems bad, you may want to consider changing the photo entirely.

Once you are satisfied with the position of the sky, press Enter to commit the transformation.

Step 5:

Go back to the layer mask and apply a bit of Gaussian Blur to give the edges of the two images a little blend. In most instances, a radius of 1.0 will do, but it's up to your

judgment on much your work should have. Afterwards, in the menu panel, click on Filter, then Others, and then select Maximum. Set the radius to 2.0, but again, if you think your work needs a bit more or less, then feel free to experiment with this tool.

The point of applying these changes in your work is to remove the light halo on the edges of the subjects. Depending on how strong or weak the brightness is on your photo, you can opt to not toggle these settings.

Step 6:

Look for Curves in the Create New Fill or Adjustment Layer button at the bottom of the Layers panel. A new dialog box will appear together with a new layer. Right click on the new layer and select the Create Clipping Mask option. On the Curves dialog box, move the line passing through the graph to adjust the balance of black, white and midtone light. This is where you should be conscious of the brightness of your landscape. Keep in mind that the sky's intensity should match the foreground. Therefore, if the contrast of the sky is too high compared to the scenery, then you should reduce its contrast.

Step 7:

Another thing you should consider is the position of the clouds. If, for instance, you are working with a cityscape, and the distant buildings are bright, then the sky above

it should be clear to give the effect that the sun is shining bright in that area. Should your photos not match, then you can apply a little gradient trick over your mask layer to make it appear that there is more light in the distance.

Select the Gradient tool from the palette, and then click on the Linear Gradient button at the options bar. Make sure the colors selected from the gradient options are Black and White. Keep the opacity at 100%. Hold the mouse at the top of your image, then drag it to just above the horizon. The line needs to be completely straight to avoid resulting to a slanted effect. Simply hold the shift key before releasing the mouse to accomplish this. Take note that this should be applied on your mask layer.

When you are done applying the effect, you will notice how the added depth enhanced the drama of the sky. The upper portion of the image lightened, while the lower darkened. If, however, you want this inversed, you only need to interchange where you started drawing the gradient line. In this case, you start from the horizon going up.

You can also try playing with other gradient options, like the Radius Gradient or the Reflected Gradient. Try applying these on your image as well and see which will bring out the best effect. After all, you also need to consider the position of the clouds to determine where the lighter portion of the sky should be.

Step 8:

Repeat the instructions in Step 6. You need to create a second curve adjustment to further establish the light source of your image. For example, if the buildings or objects on the right side of your photo are brighter than the ones on the left, then the left portion of the sky should display more light. Despite being optional, this step is also necessary for it can further hide the seams of your Photoshop work.

Should your sky photo have that warm afternoon glow, you can adjust the RGB curves of your landscape to make it appear that the buildings, or objects, are softly bathing in orange light. Simply click the dropdown menu with the RGB text, and select a different color (e.g. Red, Green, and Blue). The line on the grid will change color afterwards. Move and adjust this according to your image's needs. Again, don't be afraid to experiment and play with Photoshop. The History panel is there to help you undo any changes you've made should you find it inappropriate.

Step 9:

To further bring out the focus of your image's light, you will apply another layer of gradient. This time, however, you need to fill the currently selected mask with black. Go to Edit in the menu panel, then Fill, and finally, select

black. Press the G key to activate the Gradient tool. Set it on Radius Gradient, then keep the black and white color selection in the options bar. Change the Mode from Normal to Screen, then look for Reverse and click its checkbox.

Determine where the sun would have been in your montage, because the center of it is where you'll start drawing the gradient. Don't drag the line too far. A short radius of light is already sufficient to bring the effect out. However, if you are working with a bright scenery, then pulling the gradient farther wouldn't hurt.

Step 10:

You are ready to merge the two images, and instead of flattening them, making use of Photoshop's stamping function will make a wiser choice. Just like the flatten function, all visible layers will merge. The difference is that in stamping, it will create a new layer (with all the changes and adjustments you've made well laminated), and not combine all the existing layers to one.

To accomplish this, go to Select, then click on Select All. Afterwards, go to Edit and choose Copy Merged. Lastly, go back to Edit and then click on Paste. A new layer will appear in the Layers panel.

For the finishing touches, keep this new layer selected and go to Filter, then Sharpen, and select Smart Sharpen.

Adjust the radius just enough to enhance the details of your image, click OK, and you're done!

Keep in mind that although this book has provided a set of techniques for you to follow, you should still learn how every tool, function, and setting were used and what changes were imposed on your photo. Knowing how each of these function will give you a more concrete idea on what should be applied in a picture, and what should be skipped. As explained before, there are no two identical photos. Each will require a different set of tweaking. Hence, some pictures may not need one or two of the adjustments instructed in the techniques, while others may require additional changes using different and unmentioned tools.

Keep in mind that creativity will help you flourish in using Photoshop. Once you know the basics, you can set out on your own edition adventure and come up with your own editing techniques.

Another important thing to remember when using Photoshop is to never stop experimenting. This book may have presented guidelines, but keep in mind that these are mere safety nets. To create truly breathtaking photos, you have to go beyond what is expected. Therefore, in the techniques enumerated above, don't be afraid to play with the sliders of the different tools and functions. See how each will affect the image, and learn what will look best on it.

Conclusion

Thank you again for downloading this book!

I hope this book was able to help you enhance your photos and bring life to every picture you edit.

The next step is to go on and apply what you've learned, and there is no better way to do this than to sit in front of your computer, open Photoshop, and follow the instructions enumerated in the techniques. One good aspect of digital editing is the Undo function. This is what makes learning this skill worthwhile. Committing mistakes won't be expensive and heartbreaking – unless, of course, you accidentally override the original one-of-a-kind photo with a poorly edited one.

You should understand as well that every moment you dedicate in using this software will earn you ample experience – and experience means skill. If you are patient enough, you might even become a Photoshop guru someday, so don't stop trying even if you don't get things right at first.

Finally, if you enjoyed this book, then I'd like to ask you for a favour, would you be kind enough to leave a review for this book on Amazon? It'd be greatly appreciated!

Thank you and good luck!

The Photoshop Handbook

Advanced Ways to Create Visually Stunning and Breathtaking Photos

Introduction

If you have ever seen a stunning photograph, you will know that the image that you are looking at has been well thought out from many perspectives. The first will be composition, since the composition of an image is vital to its presentation. The second thing that you will notice is the depth of the image and the way it draws you into it. This may be achieved by intensity of color or by the fact that the photographer has used his unique style and what the photograph presents is original.

There are so many photographs of everything in this world, though making images that stand out from the crowd is easier than you may imagine. Of course, you need a certain amount of photographic ability and would need to know the rules of composition, how to use light and reflection as well as knowing how to enhance the photograph using your Photoshop software. The better composed and planned the photograph is, the better the results, even if you intend to use Photoshop.

One of the rules that you should bear in mind is that you shouldn't use Photoshop to make up for your lack of photographic ability or to try and make mediocre photos look stunning. You should take stunning photographs, using your knowledge of photographic theory and then use Photoshop because that is what will set your images apart from those produced by others.

The fact that you don't need to seriously crop an image is helpful because you are not losing pixels or definition.

This guide takes you through some Photoshop techniques that will help you to improve what you end up with. Regardless of the type of photograph, from portrait to landscape, you can improve your presentation after reading this book and using the techniques described.

When people look at an image and say, "It's been Photoshopped" what they are saying is that you didn't make too good a job of it because it's obvious the photograph has been doctored. When you know how to use Photoshop well, your pictures won't look like this. They will look like you got it right first time and that's where the difference is.

Follow the book for easy to use instructions that do not depend upon you being an expert at using Photoshop. This comes after time, but for now, you can practice the different techniques explained in the book until you are more confident and can use your own adjustments on your images to make them stunningly beautiful.

Chapter 1 – Assessing Photographs

When you have a batch of photographs, assess them for quality. For example, if you can zoom in on the photo, does it begin to look grainy? If it does, it's not that good a picture to work on with Photoshop. Of course, you can enhance it, but think big. Your photos need to be crisp and sharp so that whatever you do to the image, you will enhance something which is already good quality. Look at the images below and you will see what I mean. Some images are just not worth working on while others have great potential.

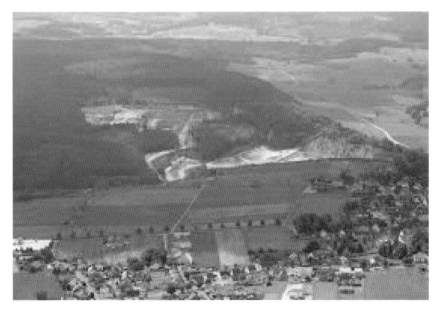

This image has a lot of great scenery, but what's missing is definition. It's too dull and it's unlikely that using Photoshop

would enhance it that much. The detail is lost because the light in which the photo was taken is not the best light, nor was it intended to capture morning mist as a feature. It's fairly bland. This would be a photograph that could be put aside as being unsuitable. However, look at the image below and this has potential. The point is that each time you go out with your camera, you will come back with a certain percentage of images that are mediocre and that can't really be enhanced that much.

The photo that we show below can be enhanced, although is fairly good anyway. The depth of field is superb for showing up the dandelion head as the feature of the image but it can be improved upon.

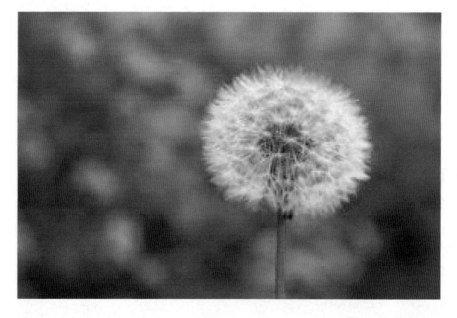

With Photoshop you are able to improve the image by adding more contrast, a little more color to the background and making

the image look more professionally produced and it's simpler than you may imagine and will be explained in detail in our chapter on enhancements to color and contrast.

What you are trying to do is to sort out the images so that you don't waste time looking through them all and can concentrate on your Photoshop session, creating superb images without wasting time. Place all the images that you have to edit into a Photoshop file so that you can devote a little time to getting your images up to scratch.

Have an idea in your head about the improvements that you want to make to your images. People go ahead and Photoshop images without really giving the overall picture a lot of thought. Think of a photograph as a painting or picture because all of the elements are important and it's the overall image that people will judge and that you will judge yourself when you see the finished product.

Once you have all your images together in one place, you can work through them making improvements and moving them out of that file and into your picture library on your computer.

Chapter 2 – Using Photoshop for Portrait work

Once you have seen the benefits of the tools available in Photoshop, you will want to practice on improving images. They say that photographs don't lie, but perhaps in this day and age, they do. What you can do with Photoshop is use the tools that are provided to help to enhance photographs in either a flattering or a fun way.

Facial features such as Eyes, Nose and Mouth

When you are working on these, there are several tools available in Photoshop which you may not have tried yet. Open up a portrait photograph in Photoshop and try some of the modifications which are detailed here, because they really can look superb. If you don't like what you have created, you don't have to save it. You can revert back to your original image.

If you look at the top of the screen in Photoshop, and press Filter, choose the Liquefy filter. This is a very useful tool to use because it allows so much enhancement to the facial features.

Look on the left hand side of the screen and there are a selection of tools that you can use. The Pucker tool is the one which will be used the most on facial areas because it allows you to do amazing things like cut down the size of a nose without the subject of the

photo having to go through the pain of nose surgery. Before you start to use the Pucker tool, you will need to choose the size of tool that you want. This is easy. Hold the tool over the area you will be working on and then resize it to fit the area you want to shrink. This is done using the slide rules on the right hand side and the top one is the resize and is marked "Brush size."

Making the Pucker tool work

In the old days of Microsoft Picture It! They had a tool which was called putty and this is very similar to that. Simply hold the tool over the area that you want to shrink and then click your mouse button and watch it shrink. You have to be a little wary of the tools at first because too much isn't necessarily a good thing. You must have seen selfies which are obviously Photoshop treated and the idea is to create as aesthetically pleasing an image as you are able to.

This image has fairly perfect proportions and would not need treatment, though the tool is placed over the nose, if you want to shrink the nose. You could also use it in areas such as cheeks if you feel that the subject's cheeks are a little too bulgy.

Look at the facial features here because there are many which you can subtly improve. For example, the eyebrows can be pushed a little higher. The lady has a very high forehead so this wouldn't look out of place. Her eyes can be made to look bigger which is always attractive and if you wanted to, you could even work on the lips so that there is more curve to the upper lip. These use a different tool in Photoshop. The bloat tool is the opposite of the Pucker tool.

Using the bloat tool

This is used in much the same way, but is a little messy. If you are working on areas as fine as lips and eyebrows or even eyes, this is not the best tool to use. However, if you want to add a bit of body to an area of the face, it's quite useful. For example, sallow cheeks can be made to look more filled so that the subject looks healthier. Simply hold the tool over the area in question and click on your button. If you don't like what you created, then you can use the re-constructional brush which will clear up any errors that you made.

Using the Forward Warp tool

This tool is very clever in that it allows you to click onto an area of the face and drag it. Thus, you can very gently increase the size of the bottom lip or add curve to the upper lip and even drag the skin underneath the eyebrows so that the eyebrows appear to be higher. Too high and they look strange, but in the image

above, the right hand eyebrow needs to be raised a little to look perfectly aligned with the left hand eye.

When working with these tools on portraits, try the different densities and sizes because what doesn't work the first time may work better with a different setting. Never be afraid to play with buttons. That's what they are there for and you will learn which tools are your favorites to enhance portrait photographs.

Chapter 3 – Adding Color to Landscapes

When you get accustomed to using Photoshop, you will learn that there is more to it than simply adding color. Any program can allow you to add color. What Photoshop allows you to do is to change areas of your landscape to draw in the eyes of the viewer and that's a little like when you are creating an oil painting. You know what the finished look needs to be but the photograph didn't quite happen as anticipated. Don't worry. Photoshop will help you to make your image stunningly beautiful.

Having an independent light meter when you take landscape photographs really is useful because it helps you to determine the exact light settings that you used when you took the photographs. It also helps you when you are dealing with the editing of your images, because you already have valuable information.

Let's start with showing you a little about adding color to your landscapes using CS2 and these enhancements should be available in Photoshop versions from this version onward. Basically, you are creating layers and these help you to add more color and texture to your image.

Click Layer at the top of the screen, then New Adjustment Layer. When you get that far, press Levels. Then choose your mode. The mode used for this exercise is Luminosity because not only

are you adding color, you are adding light to your image and that's important on images which are relatively dull.

You need to learn to use the eyedroppers which are on the right hand side of the screen because these allow you to see where your blacks and whites are located on the image and enhance them. Simply take the eye dropper for each color, press Alt on your keyboard and move the slider until you start to see where either the white or the black come into your picture. This gives you great accuracy because the picture you will end up with will improve in luminosity. Use the eye dropper to add either light or darkness.

The contrast that this gives your images is much better than you originally had. Supposing for example you had an underexposed image. It's too dark and that's a shame because the composition is perfect.

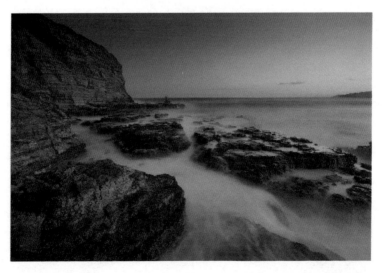

By enhancing the picture using the dropper to establish the exact light that the image should have, you get a wonderful image. The black in this image would be in the darkest area of the rocks, the white in the central cascade of the water. Now look what happens when the white and black balance are correct.

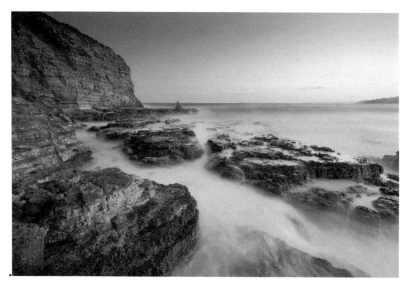

The amount of detail in the picture is enhanced and the picture looks wonderful. But you can add more color to it if you choose to.

This is by using the contrast tools. If you press Layer, New Adjustment Layer and then local the curves area, you can choose color mode. If you use the black eyedropper this shows you what happens if you choose a certain black area on the image as the one that you feel is ideal. When you find the correct balance, simply click on the area which produces the best color. It's

the same for your white but beware. The white balance on an image can really be taken from different places. For example in the above picture you could choose the white balance in the sky or you could choose the subtle white balance in the waves somewhere. Press around and experiment because as you do, you will find that you add color to the image until you are happy with the results.

Then open up a new layer pressing New Adjustment layer and press on selective color. This brings up a small box and if you adjust the mode area to color, this allows you to add more color to the image.

Look at the adjustment slides. If, for example, you feel that the sky is a little too white, you can tone it down with the sliders and then enhance the sky by adding some cyan. Think of this a little bit like the work that used to be done in the darkroom environment where adjustments were made to filters to get the image perfect. Add magenta to see this this gives your picture a little more color and don't be afraid of adjustments as these are only on layers, rather than affecting the image that you have at this stage. When you are happy with your image or think that you are, compare it with your original and then save it if you are happy with the adjustments. Color makes so much difference to the way that people perceive an image. Go too far and your image may look unrealistic but the right amount of additional color can look stunning.

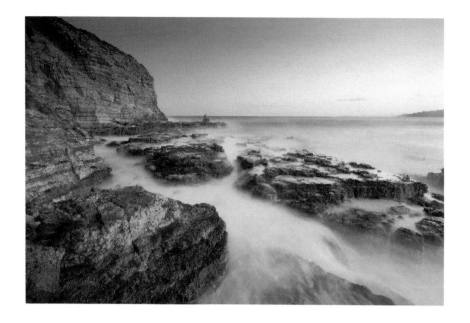

Chapter 4 - Colorizing Black and White Images

You may wonder why you want to colorize a black and white image but there are in fact many reasons. Perhaps you have old photographs of family members that were taken before color photography was popular. Perhaps you have black and white images that you just want to add a little extra color to as a special effect.

Supposing that you have an image which has sky, let's deal with adding color to this area first. In Photoshop, as you will be aware, you are always working in layers, so if you mess up, you still have your original photograph. You start adding color by using the quick selection tool. This allows you to isolate the area of the sky which is all about the same color. Remember that zooming in and using the Alt key you can work out which areas you don't want to be included in the sky area.

When you hand draw things, you tend to get crooked lines, so click on the edge refine button to neaten your edges up. The smart radius option is useful because you can choose about 5 pixels and move the smooth slider to between 3 and 4 for the best results. Then press OK. Before you start to change your picture, go down to the bottom of the screen and open a new solid layer and choose a color in the blue range for your sky.

Don't worry about accuracy for the moment, because this can be toned up or down later. Setting the blend mode to overlay, this places the color onto the image in the area that you previously marked. If there were clouds in the original sky, these should show through so that's good news. The opacity makes it more realistic. Adjust the color in the box that shows up on the right hand side, simply by moving your cursor around until you are happy with the results. Then press OK.

The layer masks allow you to clean up areas that you are not happy with. Now you can do the same thing with the background, choosing a color range that you feel is realistic for the background, going through the steps shown above for the sky area.

Remember as you go through this process for different areas of the image, you do need to zoom in to take a close look at what you have selected to become colored. If you don't do that, you may find that the colorization is a little messy. Remember, although the color you are putting over an area looks solid on the overlay layer, once it is placed over the photograph, it takes on all the shade and background detail that the original photograph had. Overlay and color settings work the best for this kind of work.

When you have finished coloring the whole image, click OK and save the image if you are happy with it. It's fun to do and can create some amazingly accurate looking photographs.

Creating special effect photos

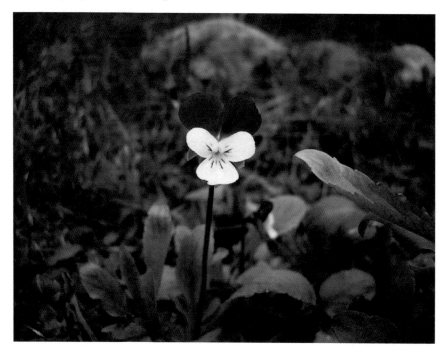

If you have a normal black and white image and want to add color to it, then you can use the same method as shown above, but refine it with painting on the detail by zooming into the image so that you know that the layers that you are adding are accurate and the small detail worked onto the image layer at the end before saving.

Chapter 5 – Giving Your Color Photographs Zing!

Enhancing the color of your photographs will always make them look better and it's easy to do using Photoshop, via various methods. To give your pictures that real wow look, you need to assess the shot. Look for areas that need to be corrected. For example:

- Are there areas which have too much shade and not enough color?

- Is the light in the picture sufficient?

- What about the clarity of the main subject of the image?

The problem is that when people take photographs, they don't think of them as a work of art and they are. Composition, brightness, focus are all important and areas of the image that you have may need a little extra help. Here's how to fix problematic areas so that your photo looks absolutely stunning.

Remember to work in layers. Thus before you start to do any alteration to your image, produce a new layer by pressing Command and J to create a new layer ready for your adjustments.

To get accustomed to the features of Photoshop that deal with this, simply press Image at the top of the screen followed by Adjustments and then Shadow and Highlight as this is a great way to get the detail really good on your image. The box that opens gives you a lot of options, but the slide bar that you need to use is the Shadow option. Put all the other bars in the shadow area back to zero so that you get a clear picture of what you are doing with your image. Now slide the shadow bar around a little and watch what it does to your image and try and hone in on the best amount of shade that gives the picture the best exposure and definition. Tonal width and radius need to be tweaked as well as it is all three of these slides that cause the shadow on the image and that will help you to produce the most realistic shadow. Even if the first slider gives results which are a little weird, don't worry about it because the others with compensate for it.

Remember when working with shadow, you are not adding color to the image and that you are merely trying to create as natural an image as possible. All the color is added later. The boxes further down relate to color and the color bar can be moved to give a little more depth to the colors in your image. The image below should have been a lot more colorful. On the day, it certainly was.

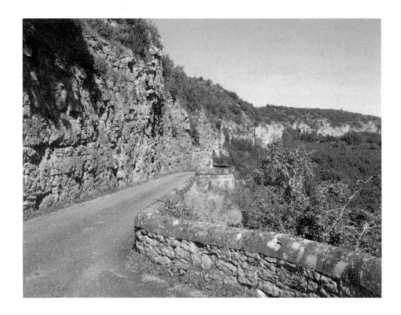

It was actually a pretty dark day when the image was taken and the sly was lot bluer.

Simply by sliding the adjustments for color and shadow to the right positions, you can make startling adjustments to your images. The thing is that with Photoshop, all you have to do is create another layer and overlay it and this can give stunning results, using the color curves. Go down to the bottom right of the screen and make another layer but with curve adjustment. This can be used to pump up any color that you feel needs it within the image. The traditional manner of doing this in the darkroom would have been to use different paper or to use the filters on the equipment, but with Photoshop you have all this built into the program. Click onto an area that you want to adjust and you will see the curve in a separate box and can adjust it and see what results it gives you until you are happy with them.

This is all fine tuning your image. You can create a new layer and grab the brush tool and use this to add color to your image, but when you do this, set it to a color which is already in the image because otherwise it will look a little false. Hold the brush over different areas to choose which color you want to put into your image using Alt which will show you the colors on the image as you move it over different areas. Then set the brush fairly large. When painting in color, use a flow that is set around 20 percent because this gives a naturalness to the paint, rather than looking blobbed onto the image. If you change the blending mode on the right hand side down to screen, this will help you to avoid having too much shadow re-introduced into the layer that you are creating. Using your layer mask will help you to eliminate introducing color to areas where you really don't want it.

Double click on the box to the left of your layer and you will be able to adjust colors. Remember that primary colors need to have other colors mixed in with them so that they don't look too false.

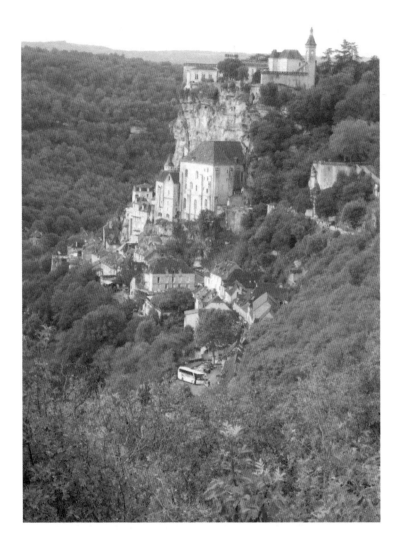

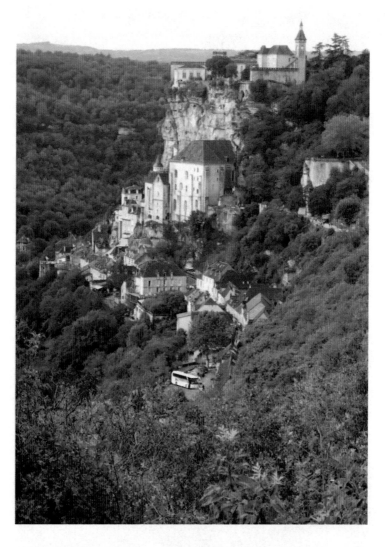

The image above could have been stunning, but it was mediocre. The light wasn't good, the focus isn't as good as it should be and with a little tweaking in Photoshop, the image really can look different, so don't give up on mediocre pictures if the subject matter is interesting enough to work with. The right hand image

has been worked on and the greens are richer, the shadows are deeper and the picture has been given a new lease of life. It's worth it to remember that if you are happy with the composition, all other elements are possible to work on with Photoshop.

Conclusion

When you have taken images, remember that making them look stunning starts with the planning. The aperture that you set your camera to and the light that is available, coupled with the composition and the quality of image are all vital. A lot of people try to opt for medium or low quality images to get more onto their memory cards. It's actually a false economy because by the time that you start to work on the image with Photoshop, you have already compromised the quality. Having a set of memory cards and changing them is a much better rule to go by because the image you get will instantly be better quality and you will be able to use Photoshop to merely enhance the areas which were a disappointment.

You can also add wonderful color filters to your pictures that perhaps you forgot to add when taking the photograph. Of course you could have colored filters if your camera has a screw mount for these, but if it hasn't then this can be corrected in Photoshop simply by adding a color layer to the image which is all over the whole image, as it would be if you used a filter.

Look at the images below and these are altered simply by adding a different colored filter.

The differences are subtle but you can also add to the luminosity of the image to make it even more stunning. The point is that you have so many choices available to you on Photoshop that it's really possible to do anything that you want to do with your images provided that the basic image itself is of good enough quality. Look how the picture springs to life with an adjustment to the light.

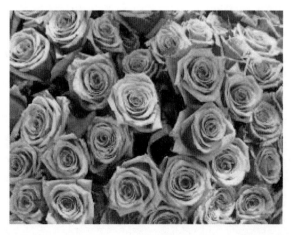

Stunning pictures can be created using Photoshop. Look at this image. The clarity is amazing and what you will see are colors that are strong and that are able to make the picture a wow picture.

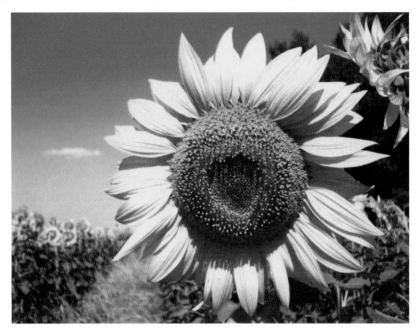

The elements that made the difference in this case was the subject matter, the composition and the light on the day that the image was taken. It's an amazing picture of nature that could be used for birthday cards or simply made larger and used as artwork on the wall of one of the rooms of your house.

Be experimental, because it's the only way you will begin to feel comfortable in Photoshop. If there's a button, press it – see what it does because you need to familiarize yourself with

all the different options and in your spare time, what you are learning is how to produce absolutely stunning images. You are also learning how to present them in such a way that they represent art and are not merely snapshots taken on the spur of the moment with no real thought given to the future of the image taken.

Photoshop tools are there to help you and once you learn how to use all the different elements available to you, your photographs really will change and become more professional looking. You may even become conscious of your own errors and learn to carry a light meter separate from your camera, as this helps you to produce much better and much more accurate results than depending upon the built in light meter in your camera.

Preview of "DSLR Photography Made Easy: Simple Tips on How You Can Get Visually Stunning Images Using Your DSLR"

Chapter 1 - What Did I just Buy?

"It's the man that makes the clothes and not the other way around."

The same thing can be said about cameras. No matter how technologically-advanced your equipment may be, your shots will only be as good as how well you handle the camera and composed your photographs.

Unfortunately, cameras are slightly more complex than clothes. And understanding how your new DSLR works is one of the most important steps you should take before getting those studio-quality shots.

THE BASICS

The acronym DSLR stands for Digital Single-Lens Reflex. Understanding this term will help you better appreciate what makes a DSLR camera different from anything else.

As opposed to thinking of a camera with a complex array of lenses, the term "single-lens" refers to the notion that both the

photographer and film (or digital image capturing surface) are looking through the same lens. There is no distortion between what the photographer sees and what will appear on the picture.

As compared to earlier cameras that have a separate set of lenses for the eyepiece and the film, SLR cameras allow photographers to see exactly how the picture will turn out before hitting the shutter! Older cameras do not have this function because the eyepiece is separate from the camera lens.

This feature allows photographers to judge the quality of their images even before calling the shot. They can adjust the light, change the lens, re-adjust the focus and anything else they feel that will help make a better shot.

That explains the SLR part.

Take note that there are non-digital SLR cameras that still use film. That's why they are simply called SLR's. The difference between SLR cameras and DSLR cameras is how the cameras capture the image.

Both SLR and DSLR cameras host a single lens through which the light rays pass through. While the shot hasn't been taken, the light rays from the primary lens hit a mirror tilted at a 45 degree angle. This will cause the light rays to go upward instead of hitting the rear portion of the camera.

When the now-vertical light rays bounce upward, they encounter a small system of prisms that direct the light rays to a smaller outlet known as the eyepiece. This is where the photographer

sees the image before being shot. Since the user is being fed the light rays directly from the main lens, they get an exact "preview" of how the image is going to come out.

When the user hits the shutter, the mirror that bended the light at 45 degrees flips upward, blocking the prism system at the top which allows the light to pass right on through to the rear portion of the camera.

This is where the difference between SLR's and DSLR's come in. Instead of having the light rays hit a sheet of film to capture the image, DSLR's host a digital-imaging sensor that captures the image and translates it into a digital image to be saved unto a storage device. Once the shot has been taken, the mirror slips back into original 45 degree angle spot to once again redirect light back to the eyepiece...

To continue reading this book, you can purchase it on Amazon at http://www.amazon.com/dp/ BooSOTKUCC

Made in the USA
Lexington, KY
04 August 2015